Un livre des aquarelles SMoss

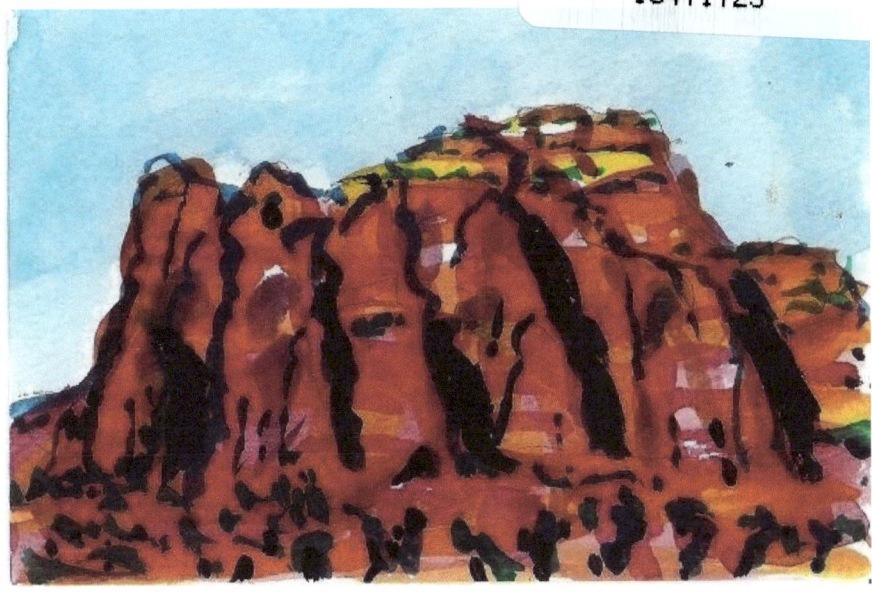

Red Rocks, Sedona AZ

'HcT! Boooks

Un livre des aquarelles
©2017 by SMoss

ISBN 978-1546995036
An 'HcT! book

All rights reserved

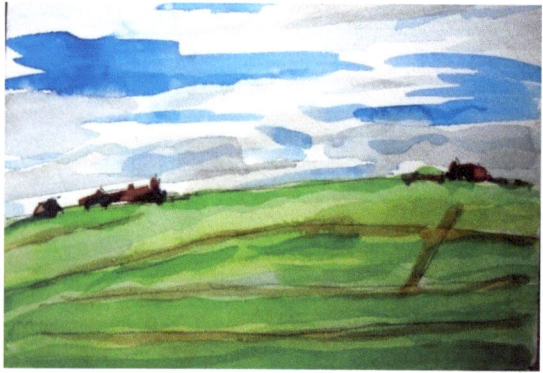

Orkney, Scotland

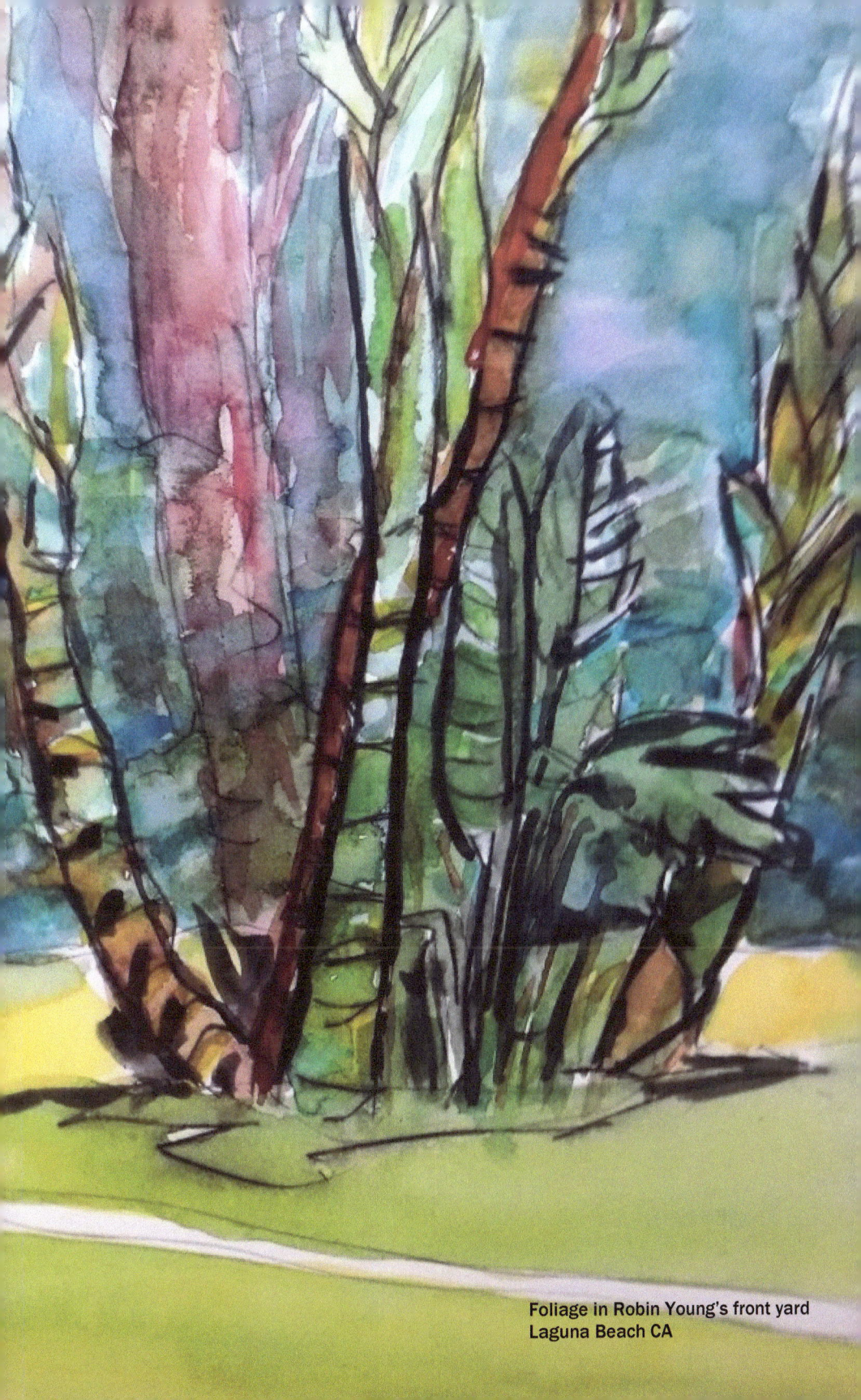
Foliage in Robin Young's front yard
Laguna Beach CA

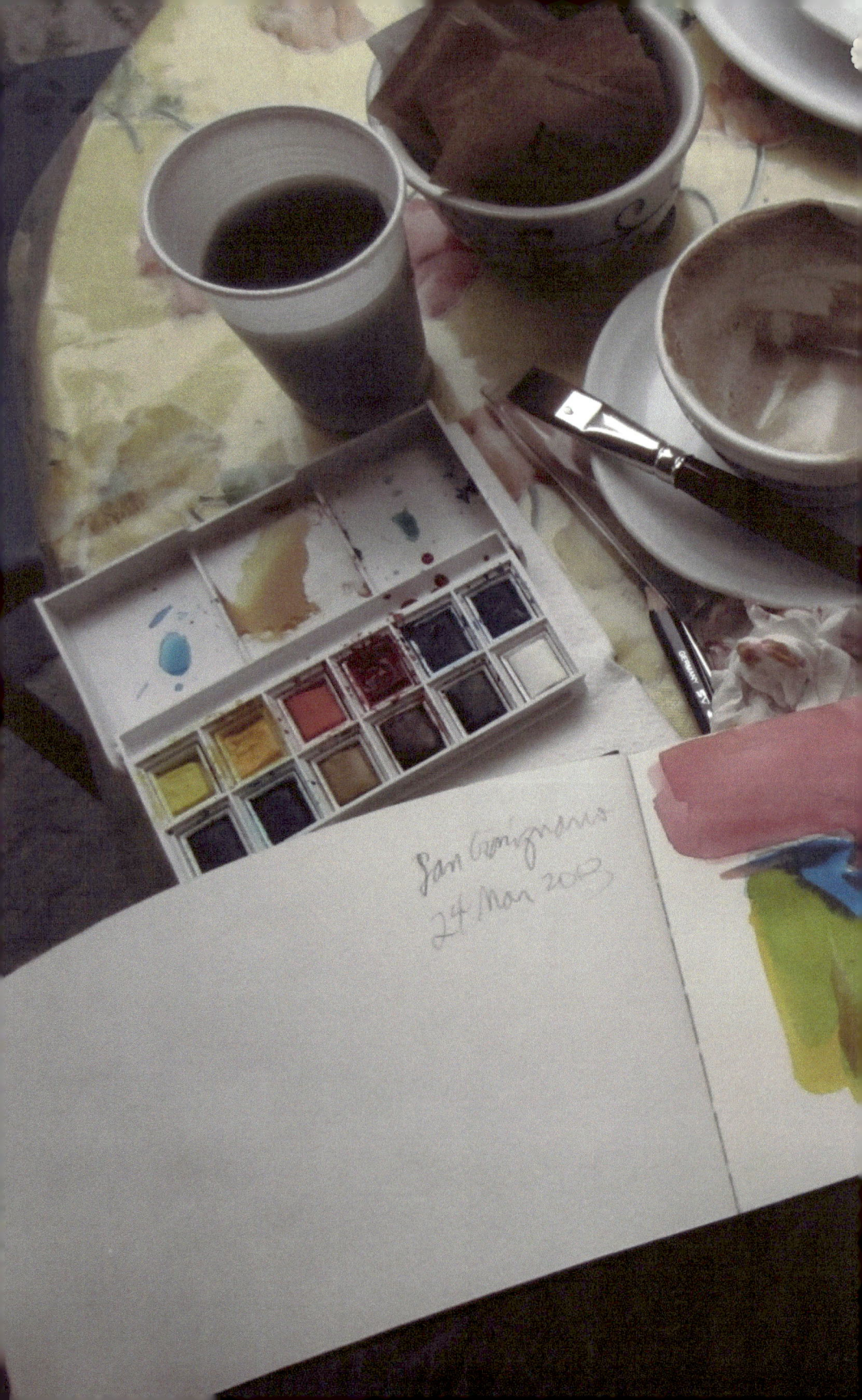

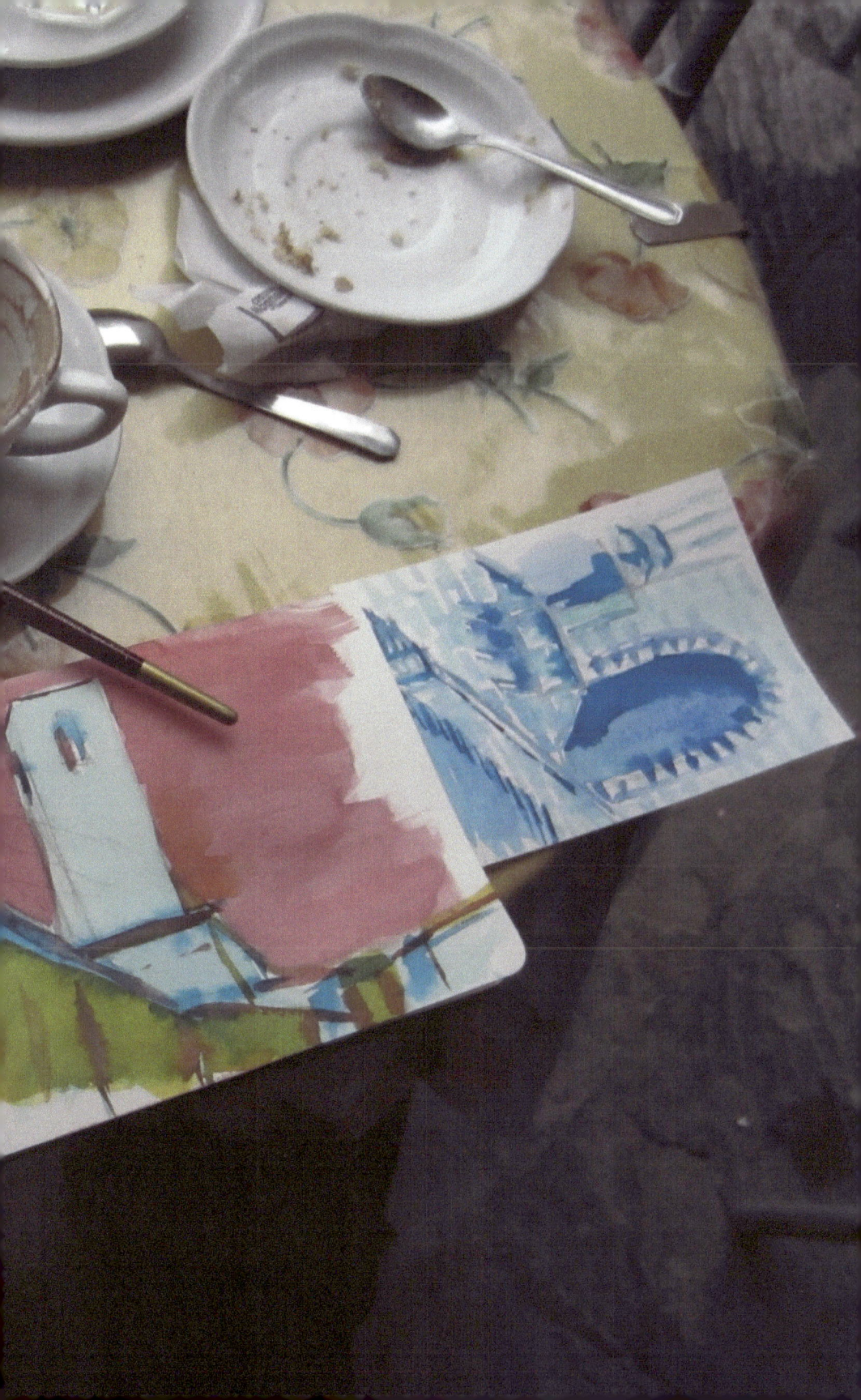

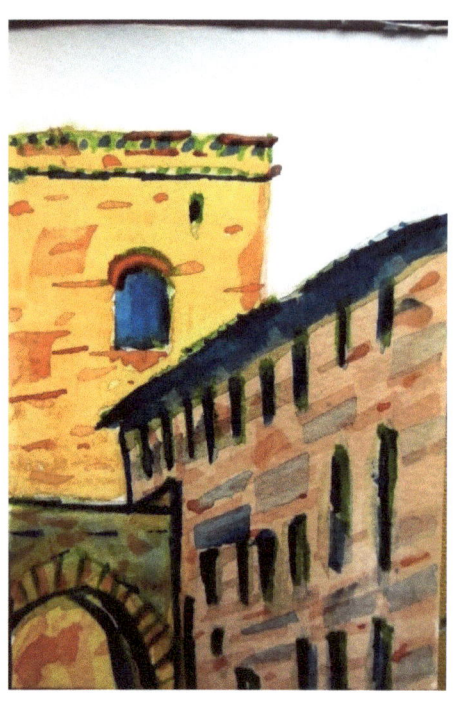
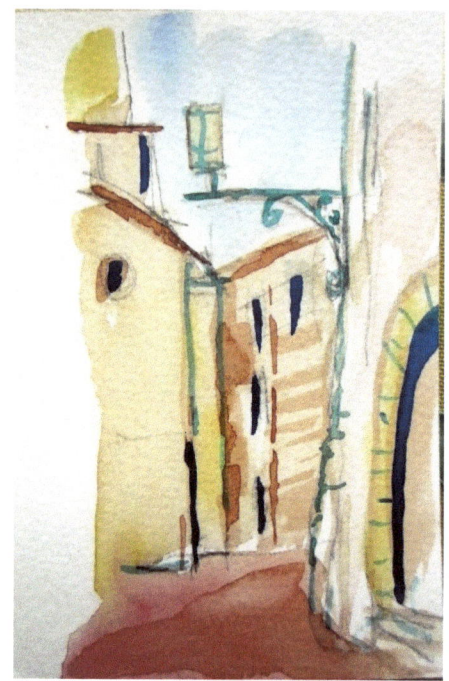

San Gimingnano, Italy

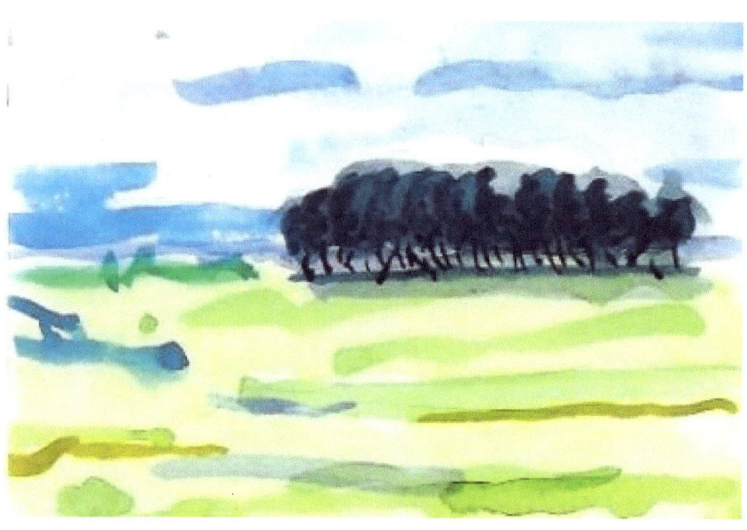

Golspie, Scotland

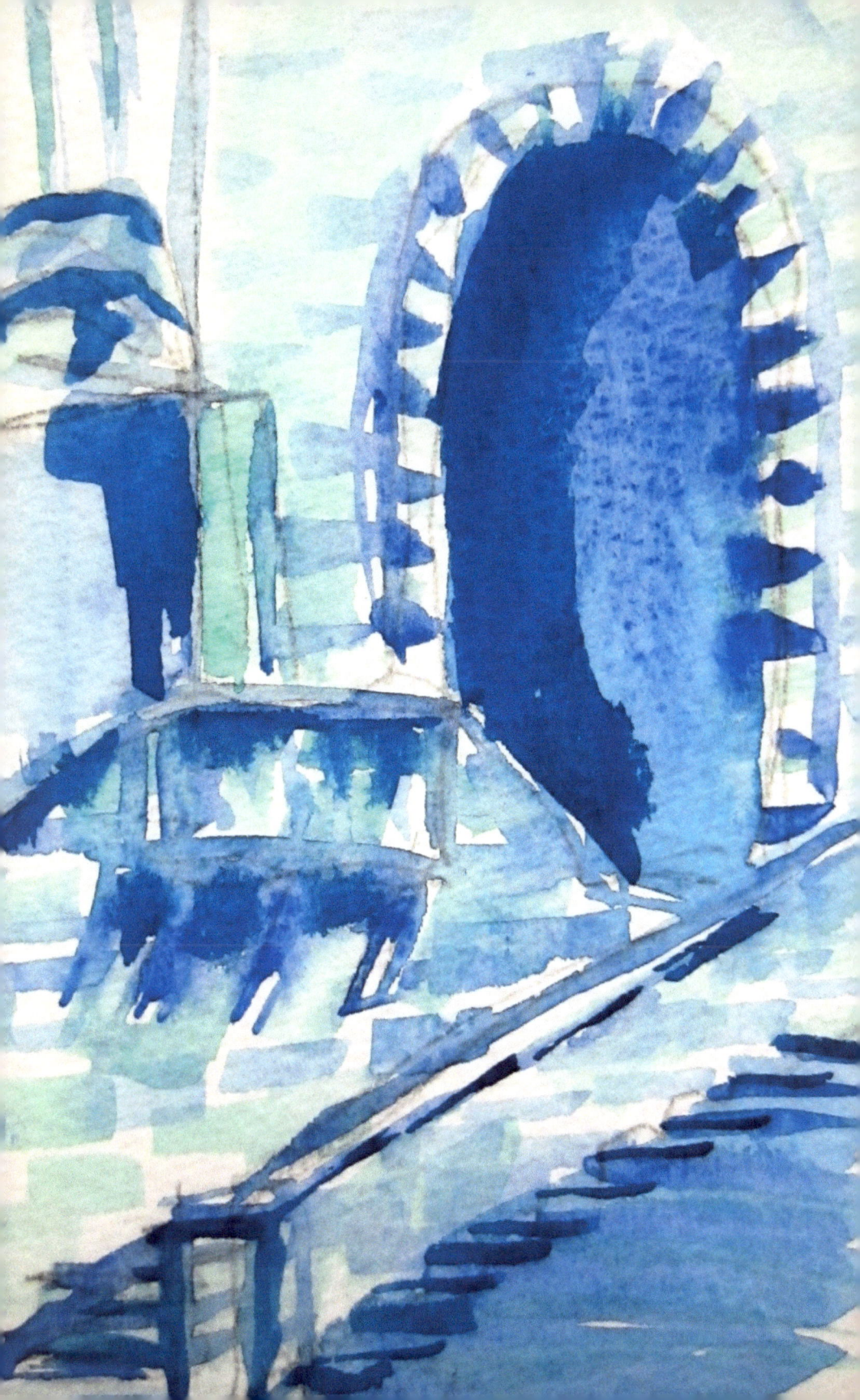

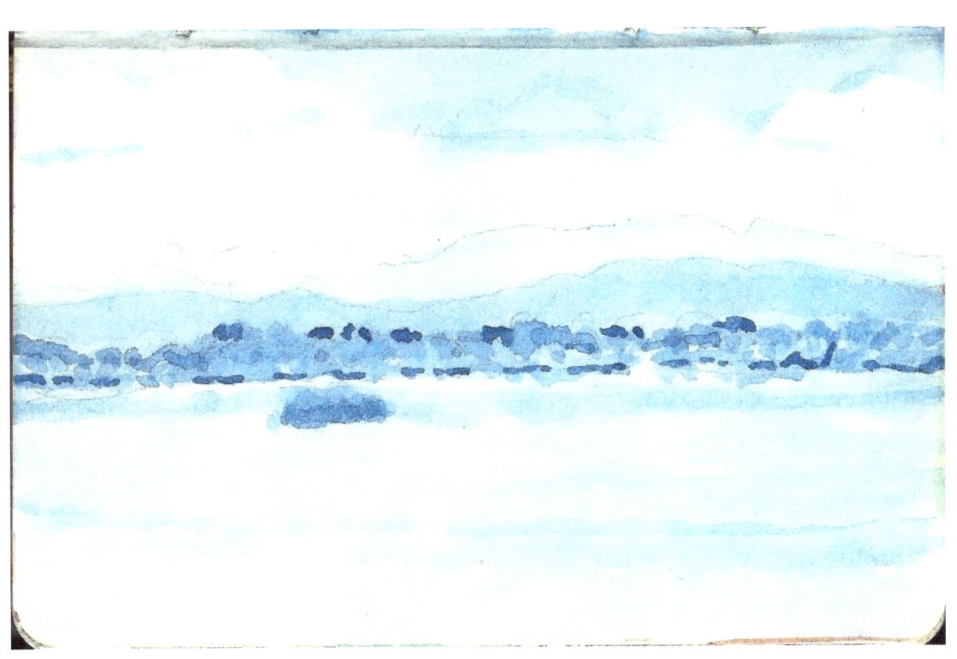

Four views of Sri Lanka

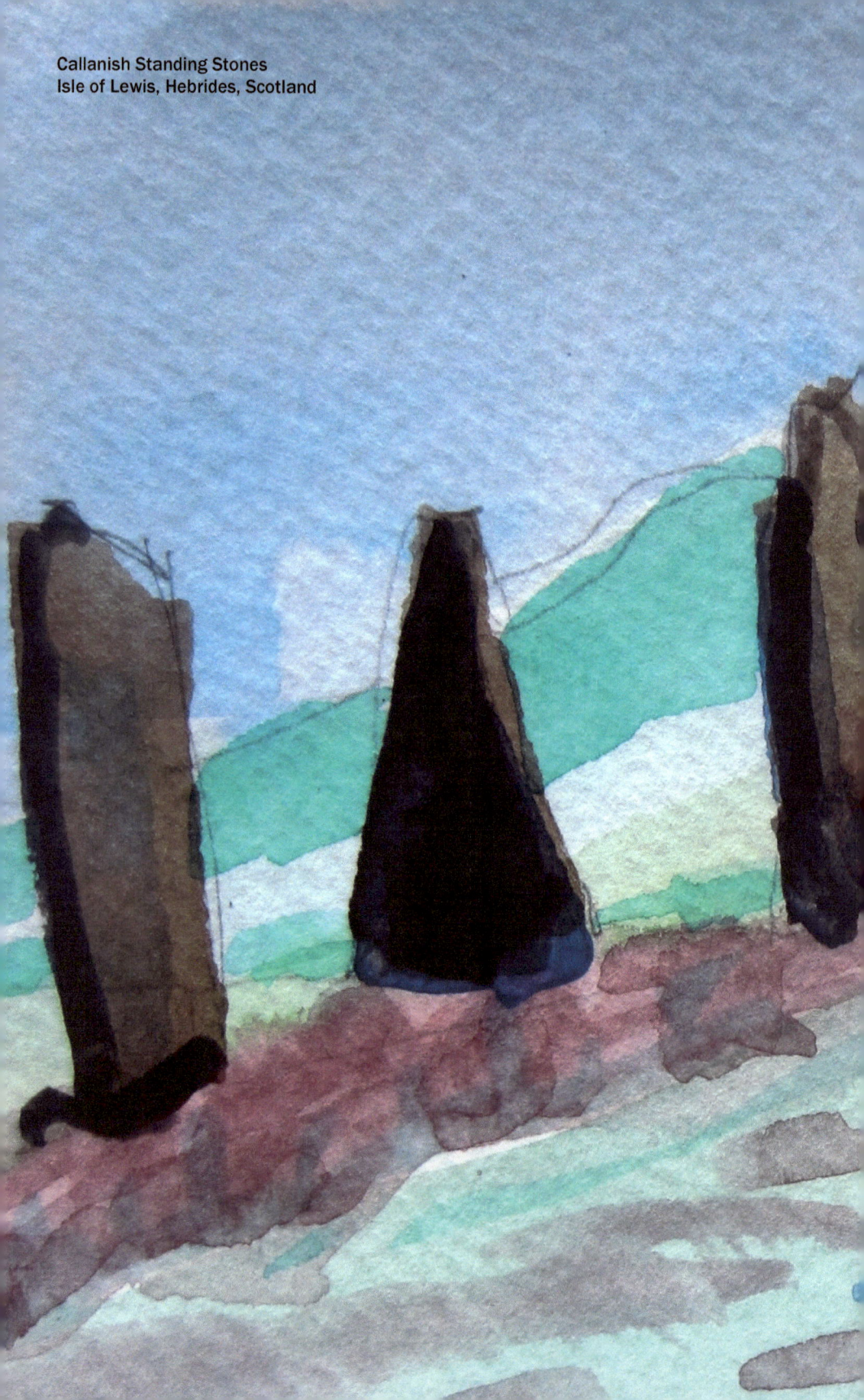
Callanish Standing Stones
Isle of Lewis, Hebrides, Scotland

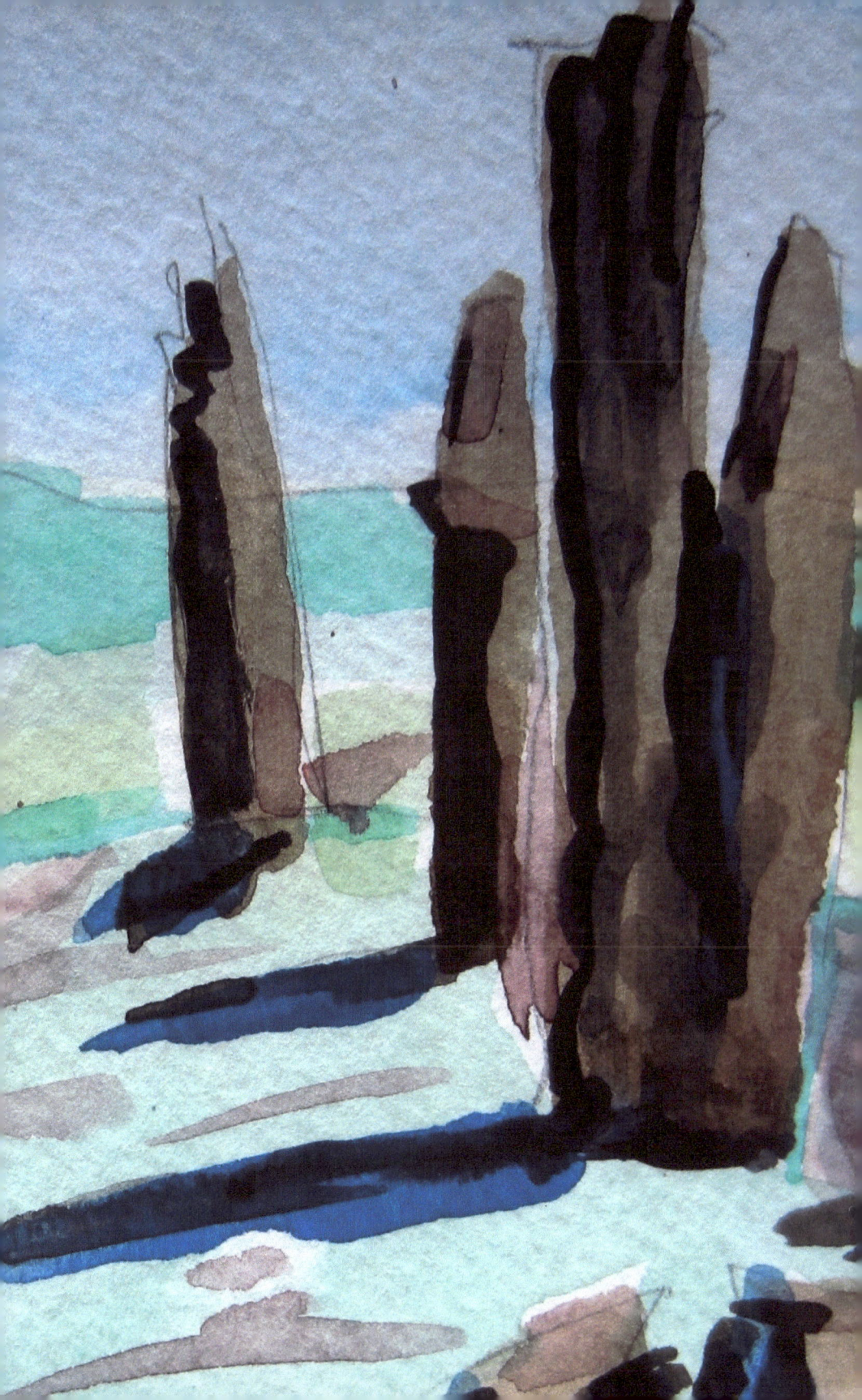

Above, painted in the rain
Below, weather cleared
Callanish Standing Stones
Isle of Lewis, Hebrides, Scotland

Opposite
3 Monochrome studies
Ring of Brodgar
Orkney, Scotland

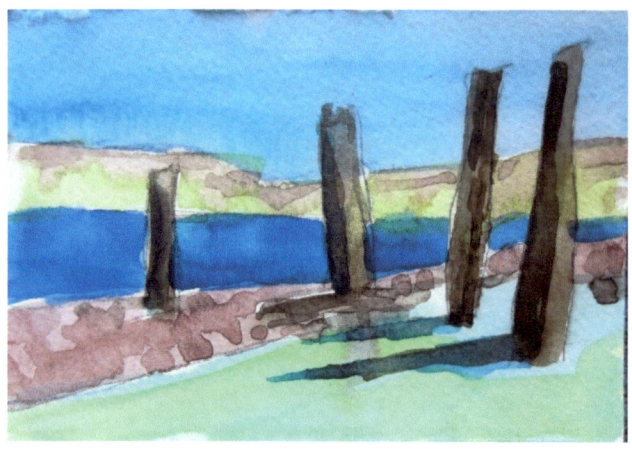

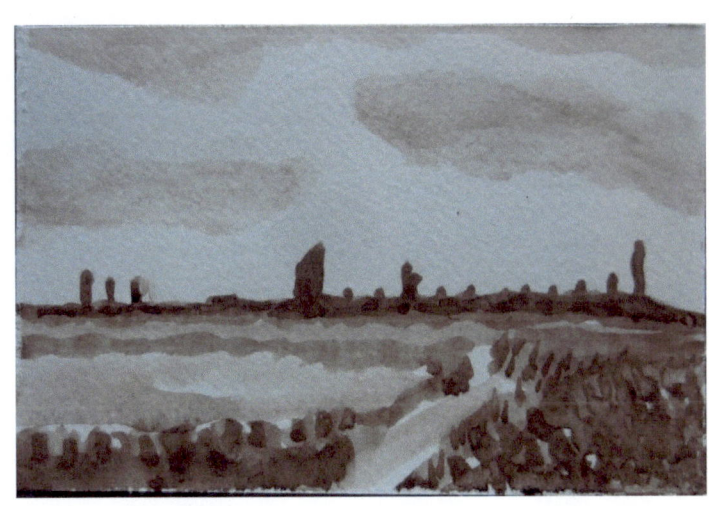
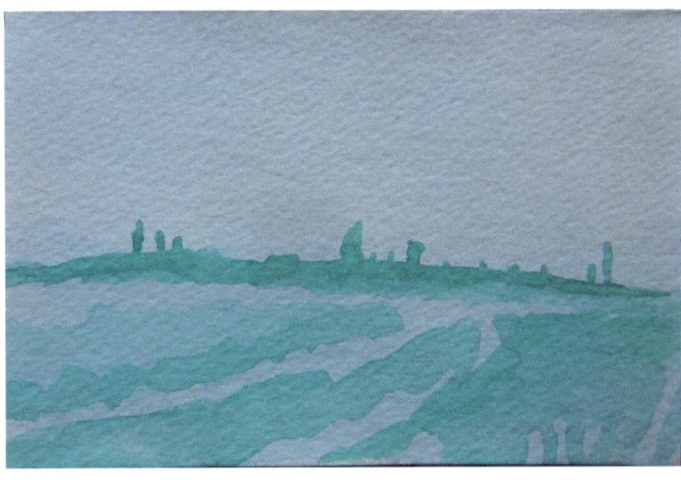
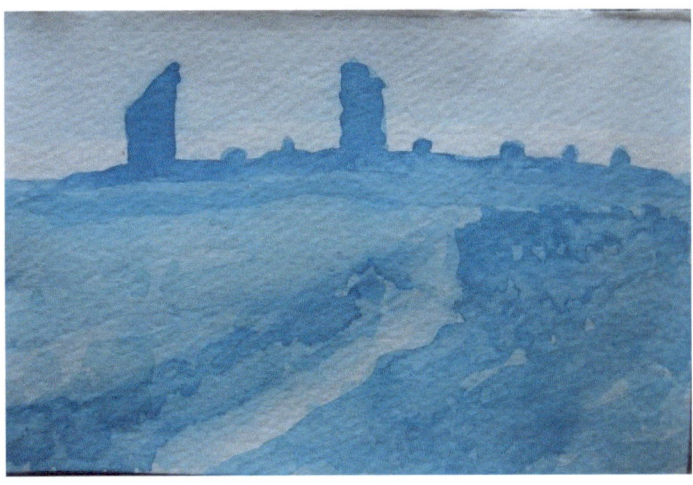

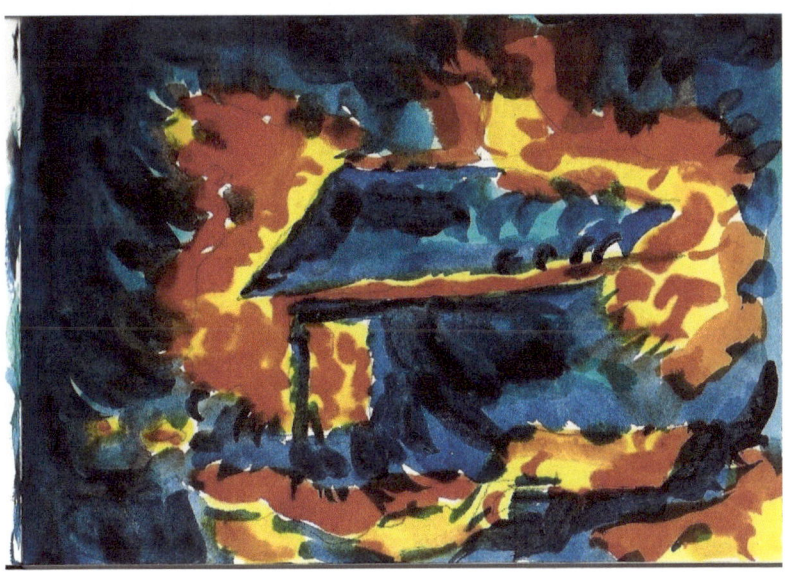

Notebook studies from 2008 Santa Barbara fires
California

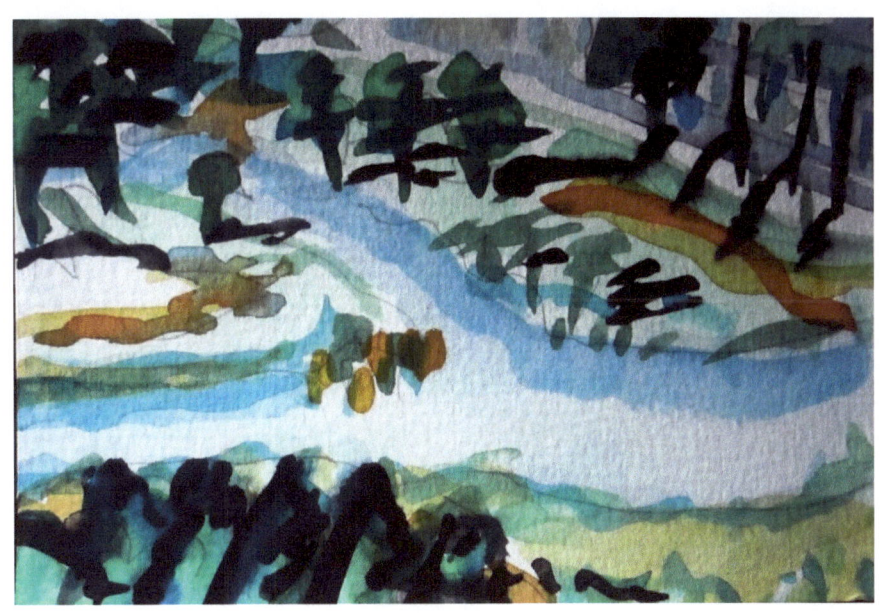

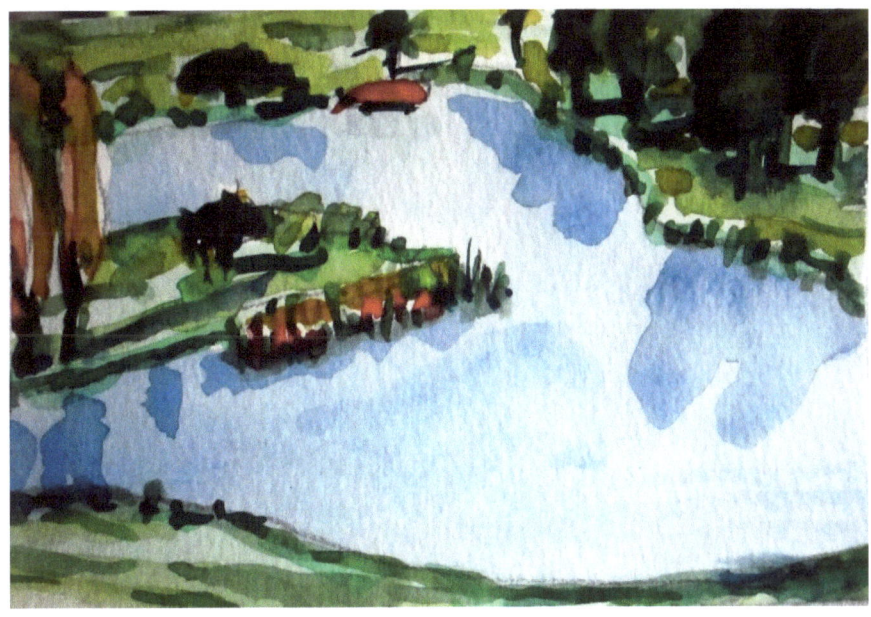

Views from Considine's house
San Diego, California

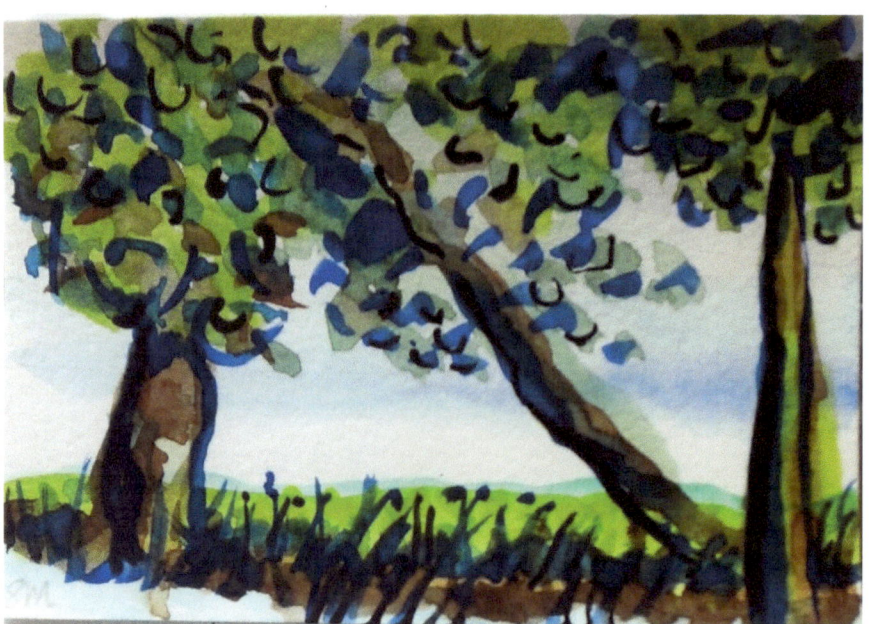

Santa Teresa, Costa Rica

Puglia, Italy

Rochemontes, Toulouse, France

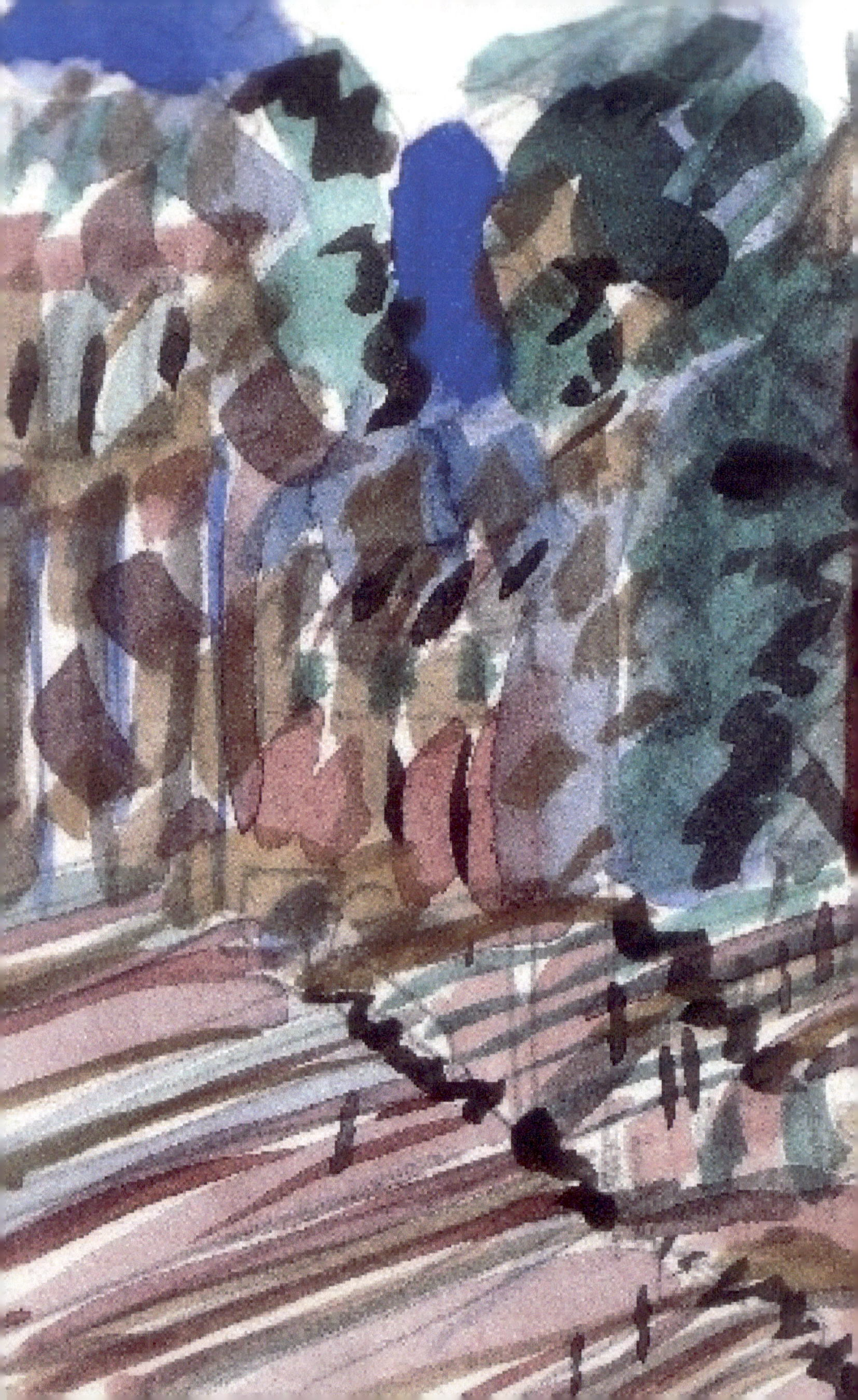

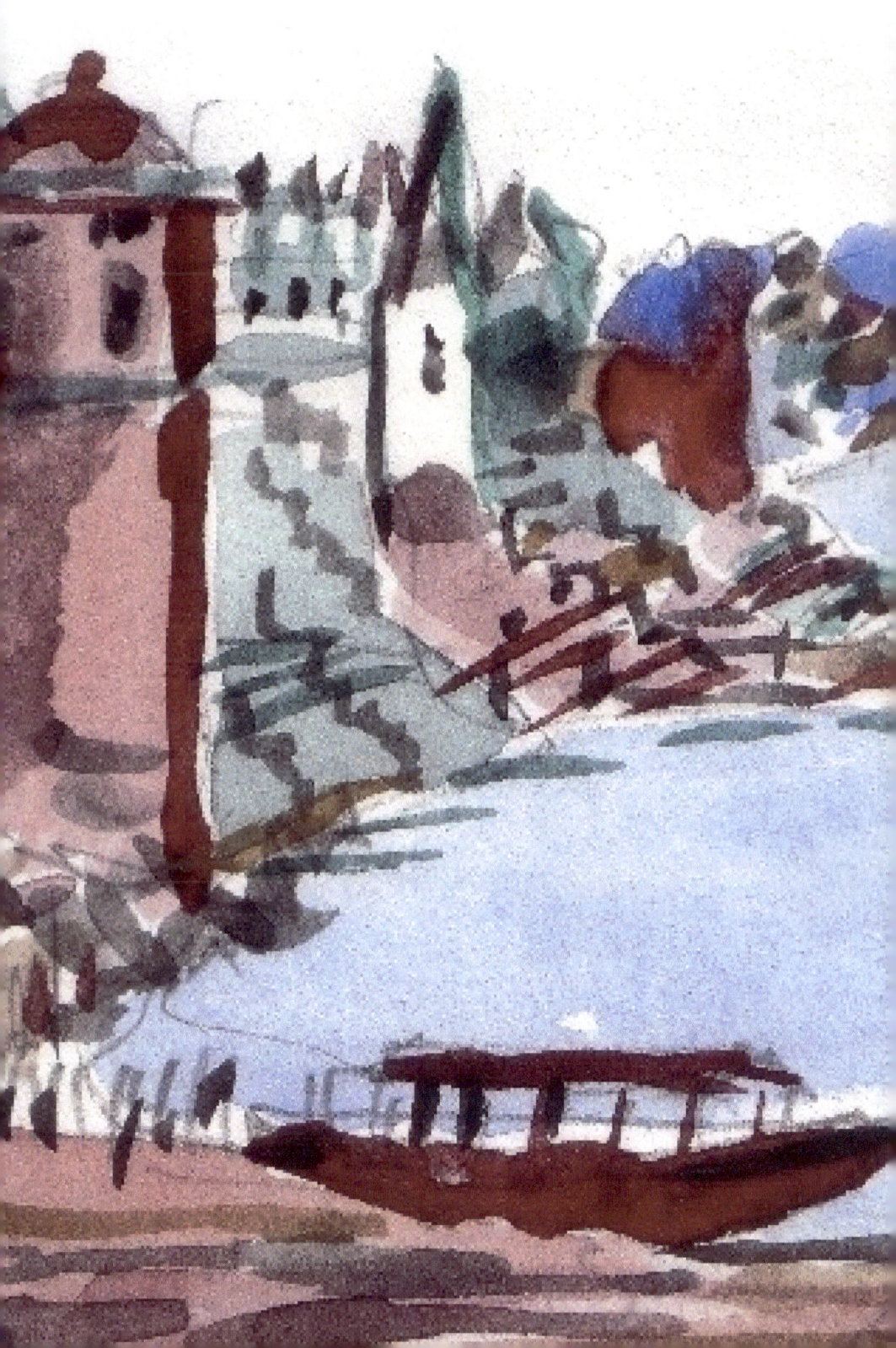
Varanasi, India

Goa, India

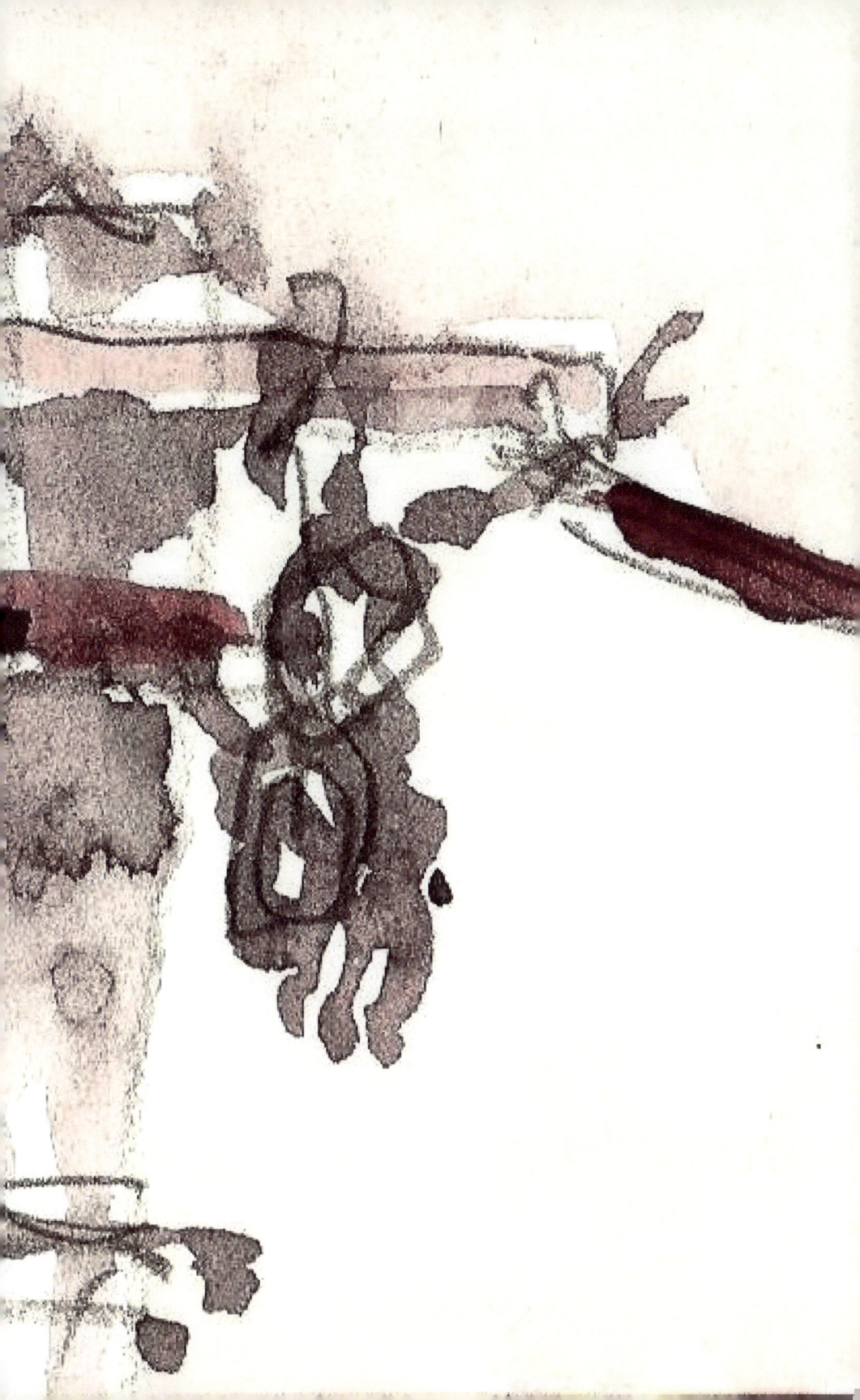

Goa, India

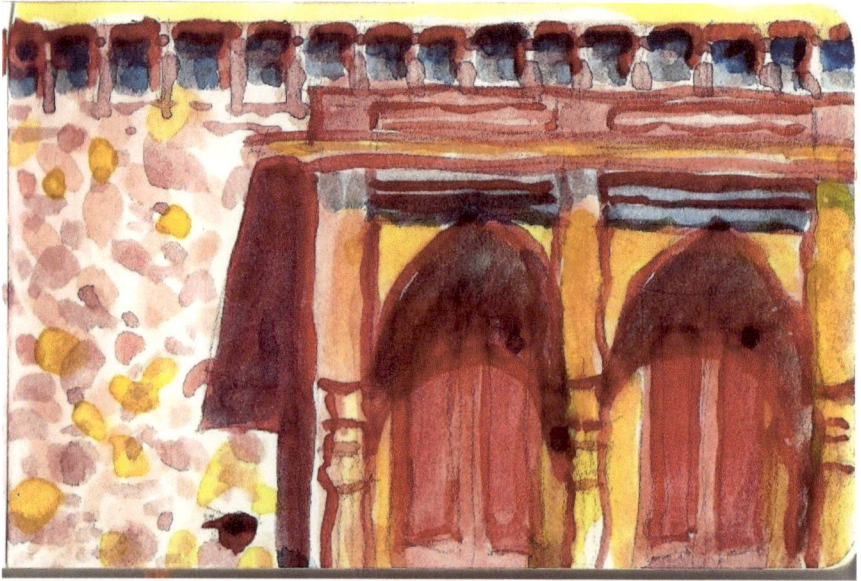

Rajasthan, India

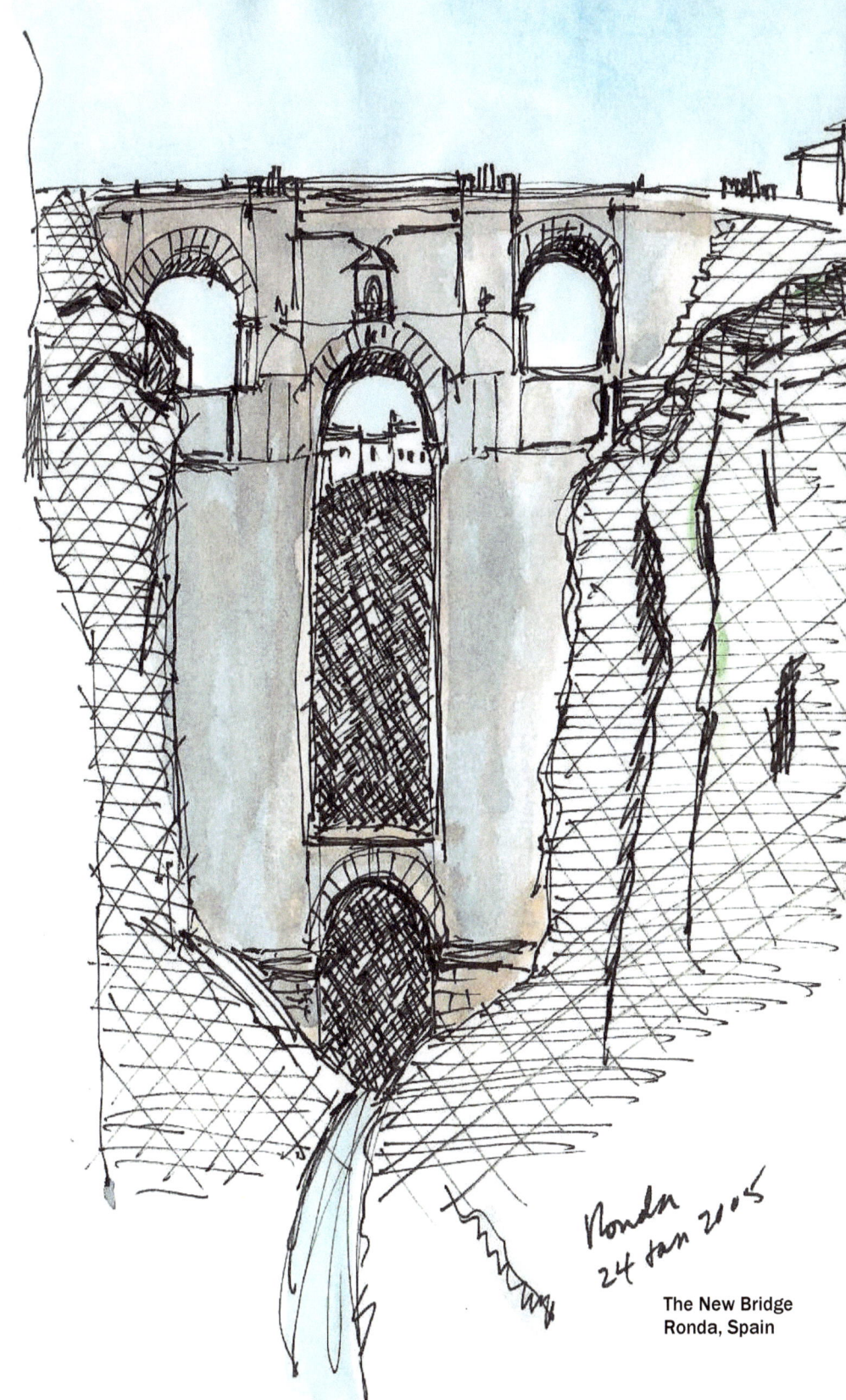

The New Bridge
Ronda, Spain

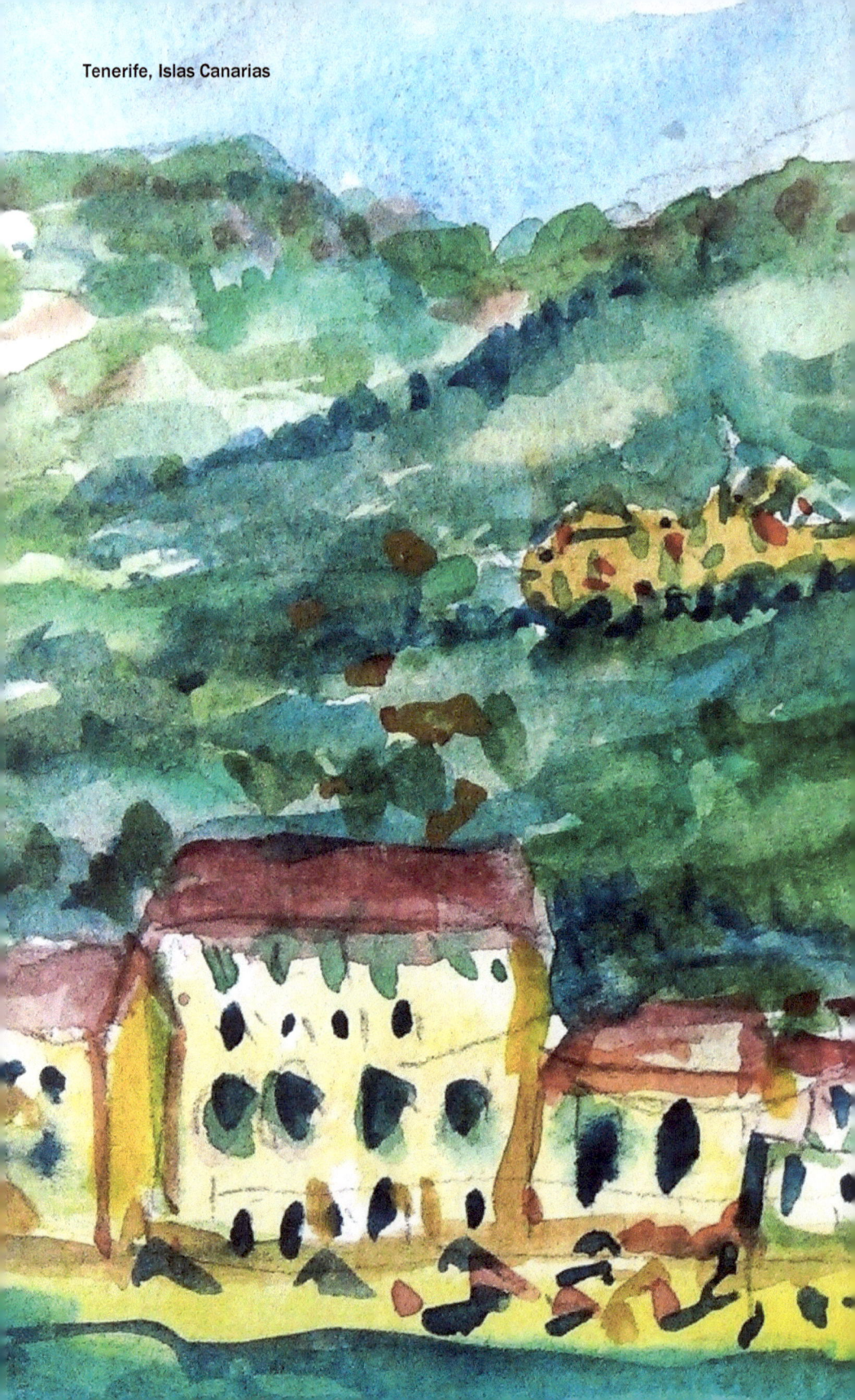
Tenerife, Islas Canarias

PS in Essaouira, Morocco
Hommage to Balthus

Somewhere in Southern Spain

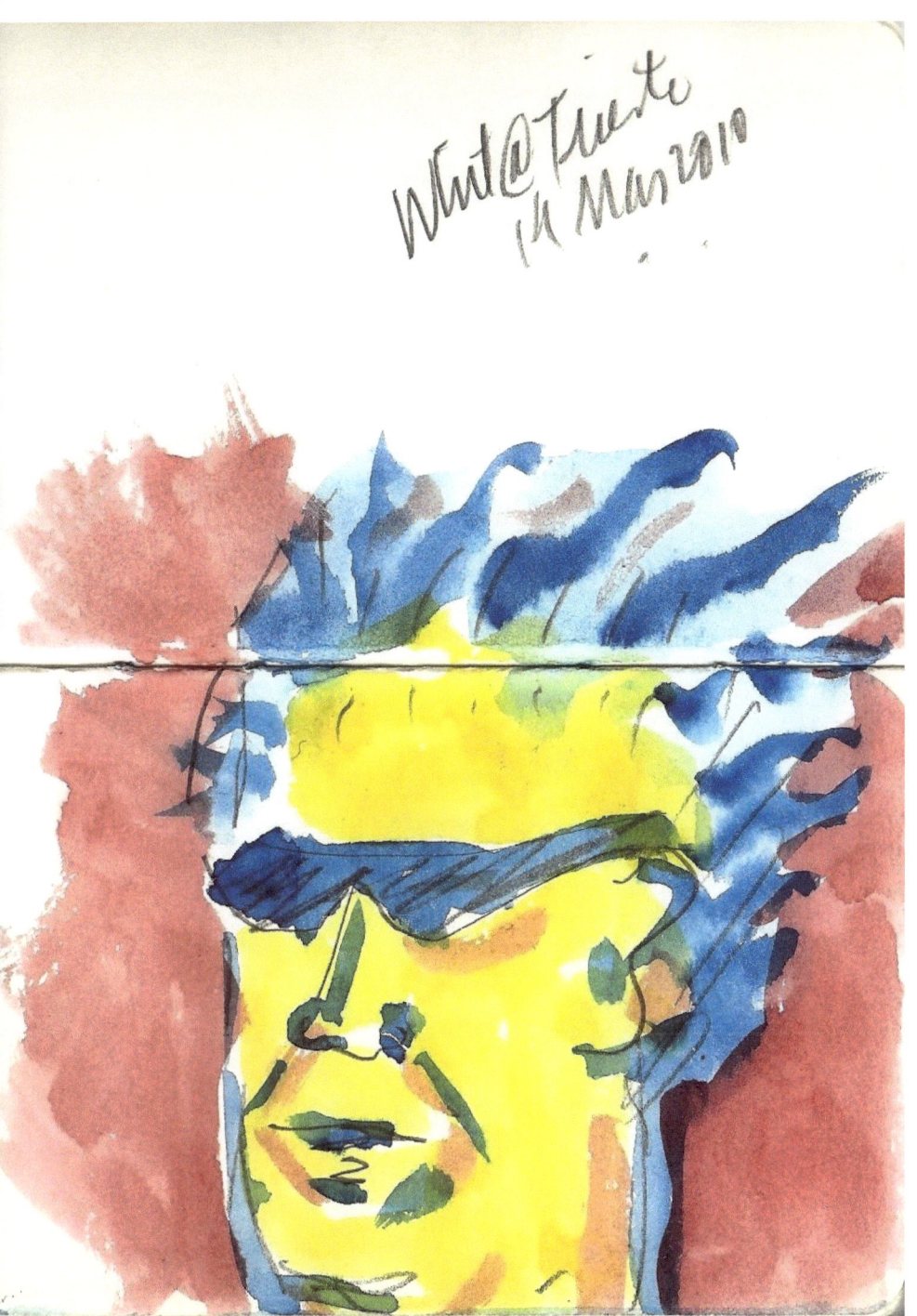

Whitman McGowan in San Francisco CA

ENJOY THESE OTHER TITLES FROM 'HcT! PRESS

111 Haikus

2014 Global Brand Letter

2015 Global Brand Letter

24 Poems *by Marco Fazzini*

Blindés *by Alexandre d'Huy*

The Blue Tibetan Poppy

The Book of Deals

Case Studies of Five Modern Labyrinths

The Captain Blackpool Trilogy
The Crimson Garter
Fate & the Pearls

Classic: *A Love Letter to Milo Reice* •

Degenerate Work *by Mike Berg*

DO NOT – *a book of rules* •

The Grandpa Trio •
Grandpa Goes Shopping
Grandpa Does Yoga
Grandpa Takes A Walk

The History & Adventures of the Bandit Joaquin Murietta

Hammam Ladies •

Hitman in Delhi, *a screenplay*

La Toux *by Pierre d'Huy*

Layers of Humankind

Leaving Your Dragon

Legacy & Power

Mandalas *by Cat Soubbotnik*

Marrakech: *A Friendly Travel Guide to The Medina* •

Oasis: *A Love Letter to Rancho Dulce* •

Park Avenue Poop

Paula's Proverbs, Volume I •
Paula's Proverbs, Volume II •

Return to Paradise: *A Love Letter to Catalina* •

Riding the Storm *by Marco Fazzini*

Supari

Supernatural

Surf City: *A Love Letter to Santa Teresa*

Swami Gopal Buri

Time Out For Dragon!

VSB •

The Vicentini •

What Is A Brand?

• 'HcT! books by Paula Sweet

San Juan Islands
Washington state USA

www.ingramcontent.com/pod-product-compliance
Lightning Source LLC
Chambersburg PA
CBHW041119180526
45172CB00001B/326